SuperVisions

GEOMETRIC OPTICAL ILLUSIONS

Al Seckel

Sterling Publishing Co., Inc.
New York

Art/Photo credits, courtesy and copyright 2005 the artist:

p. 32 — Jerry Andrus

p. 19 — Exploratorium

p. 59 — Shigeo Fukuda

pp. 8, 34, 43, 46, 65, 68, 76, 80, 86, 92 — Akiyoshi Kitaoka

pp. 7, 20, 58 — Baingio Pinna

pp. 9, 44 — Dale Purves

p. 27 — Roger Shepard

p. 49 — Nicholas Wade

Book Design: Lucy Wilner
Editor: Rodman Pilgrim Neumann

Library of Congress Cataloging-in-Publication Data

Seckel, Al.
　　Super visions : geometric optical illusions / Al Seckel.
　　　　p. cm.
　　Includes index.
　　ISBN 1-4027-1831-4
　　1. Optical illusions. 2. Geometry. I. Title.
　　QP495.S436 2005
　　152.14'8--dc22

2005002372

2 4 6 8 10 9 7 5 3 1

Published by Sterling Publishing Co., Inc.
387 Park Avenue South, New York, NY 10016
© 2005 by Al Seckel
Distributed in Canada by Sterling Publishing
ᶜ/o Canadian Manda Group, 165 Dufferin Street
Toronto, Ontario, Canada M6K 3H6
Distributed in Great Britain by Chrysalis Books Group PLC
The Chrysalis Building, Bramley Road, London W10 6SP, England
Distributed in Australia by Capricorn Link (Australia) Pty. Ltd.
P.O. Box 704, Windsor, NSW 2756, Australia

Printed in China
All rights reserved

Sterling ISBN 1-4027-1831-4

For information about custom editions, special sales, premium and
corporate purchases, please contact Sterling Special Sales
Department at 800-805-5489 or specialsales@sterlingpub.com.

CONTENTS

INTRODUCTION

They say "seeing is believing," but that will not be the case when you carefully examine the geometrical illusions collected in this book. The illusions in this volume represent some of the most powerful optical illusions known, and, in many cases, you will not even know that you are being fooled until after you read the captions. Then you will exclaim, "No way!" Given the nature of the ability of these illusions to trick you, it is strongly recommended that you keep a ruler handy to check the captions. Trust me, you will want to check. The illusions in this volume will cause you to experience a powerful mental disconnect with what you perceive to be true, but at the same time know to be false. It does not matter how old you are, what your background is, your gender, ethnicity, or even how intelligent you are, you will not be able override the illusory effects, even though you know that you are being completely mislead.

This is because your brain is constantly interpreting images in a certain way, and the illusions in this book have been specially contrived to take advantage of the way your brain can be mislead by its rules for interpreting images.

Although in some sense, all the illusions in this book are puzzlers, they are not an intelligence test. These illusions are all meant to be fun! Share them with your friends and watch how they won't believe their own eyes.

—Al Seckel

Shepard's Tabletop Illusion

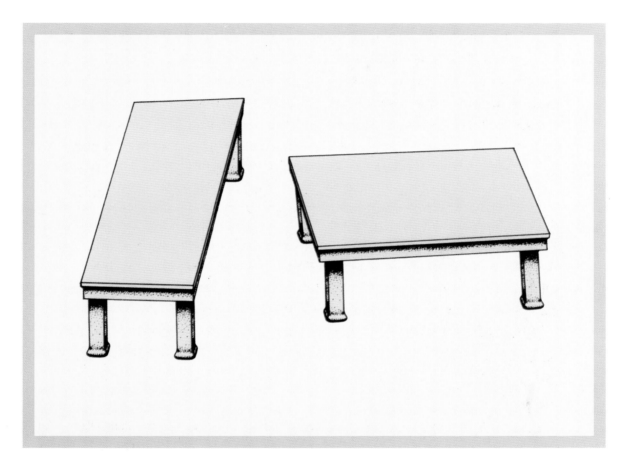

Believe it or not, both tabletops are identical in size and shape!
Carefully trace them to check your answer.

Fraser Spiral

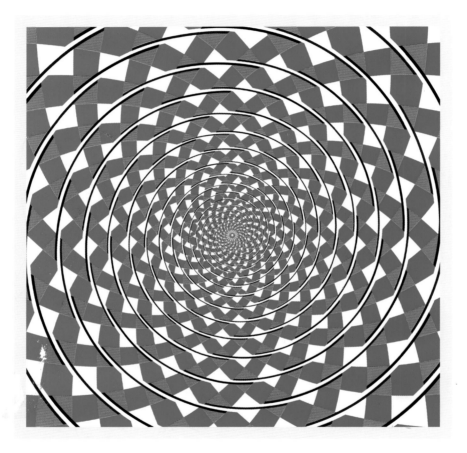

Do you perceive a spiral? It is really a series of concentric circles.
Cover half the image to test your answer.

Pinna's Intertwining Illusion

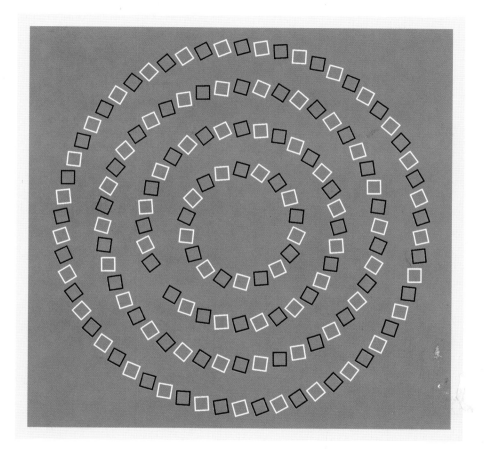

Do these circles look like they cross each other?
They don't! They are perfect circles.

Café Escher

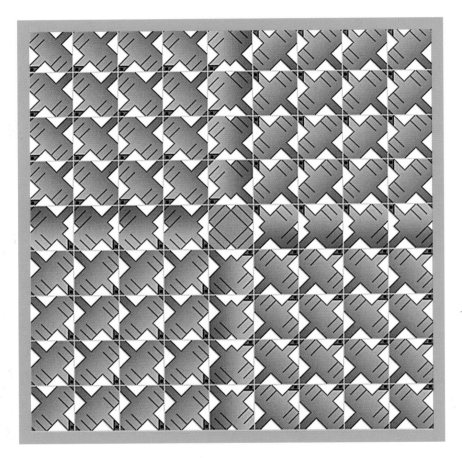

Are the horizontal and vertical lines all straight and parallel to each other?
Check your answer with a straightedge.

Purves and Lotto's Perspective Illusion

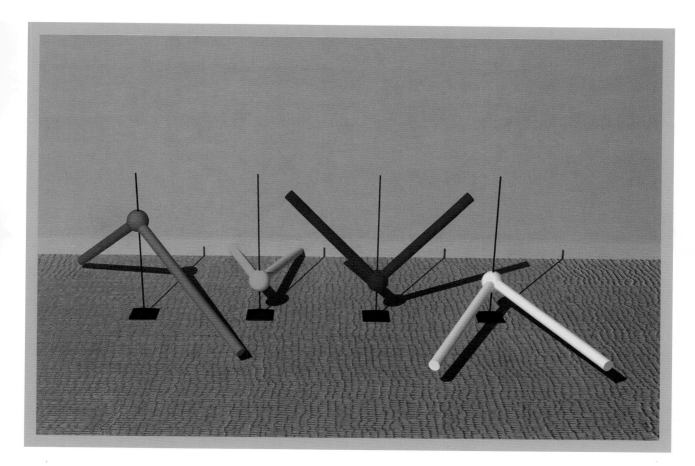

Which colored angle appears the largest? Which appears to be the smallest angle?
Check your answer, and you might be quite surprised.

Wundt's Illusion

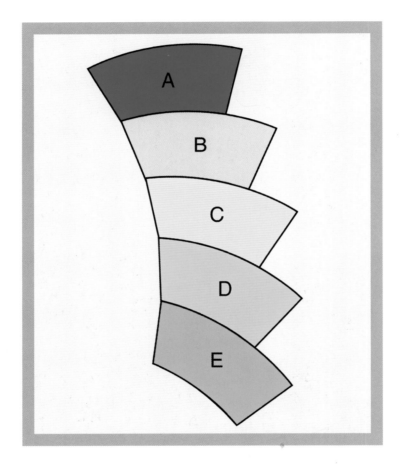

Which is the largest piece? Or are they all the same size?
Check your answer.

An Illusion of Extent

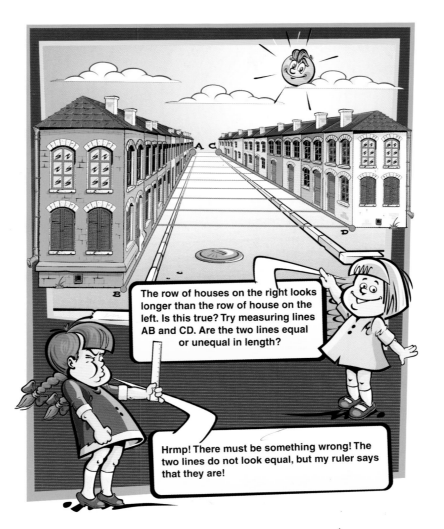

The Müller-Lyer Illusion

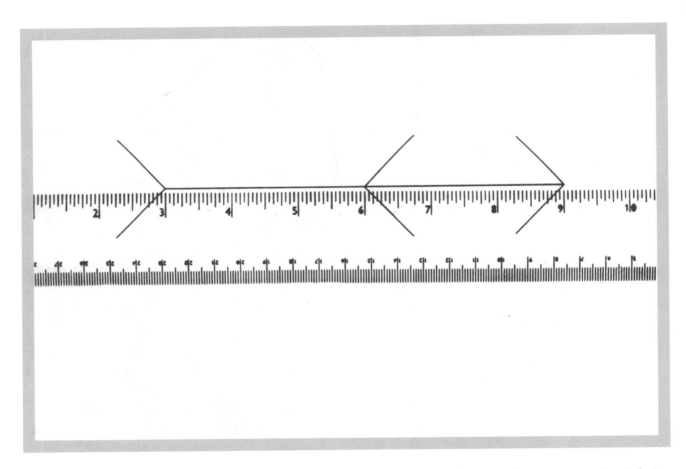

Is the line on the left in between the arrows longer than the line in between the arrows on the right? Check your answer.

Concentric Box Illusion

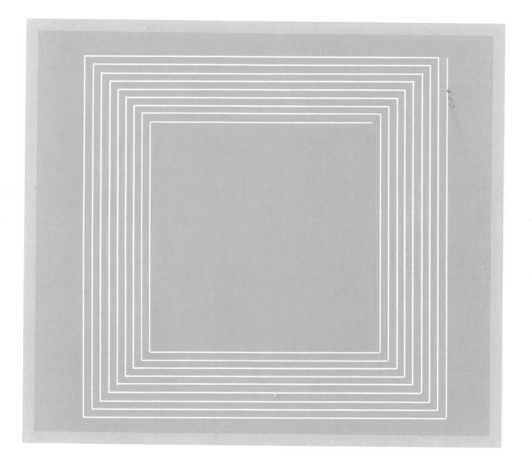

Do you perceive perfect squares one within the other?
Or is it one continuous line?

Gerbino's Illusion

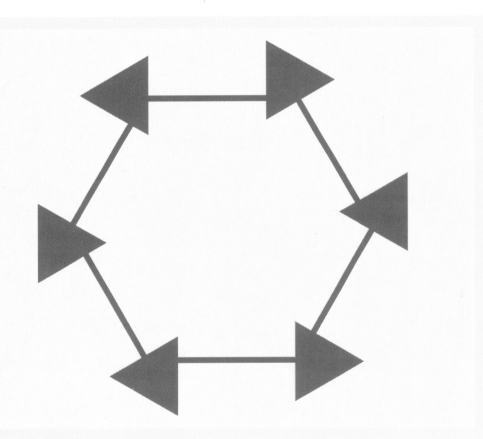

Do the line segments seem to be misaligned underneath the triangles?
Do the lines intersect with each other perfectly?

Tolansky's Curvature Illusion

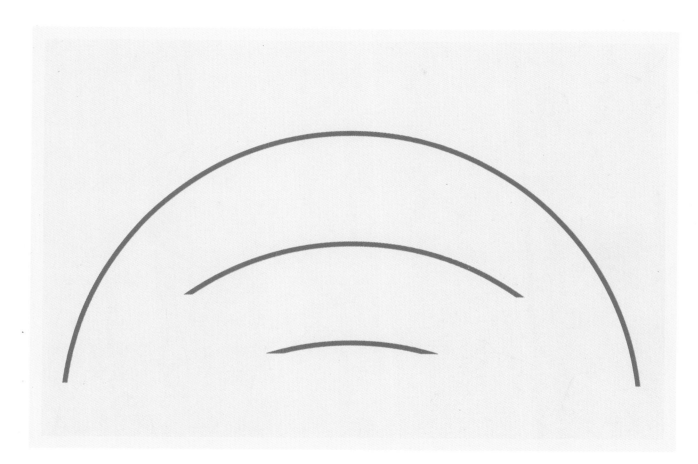

Which line segment has the greatest radius of curvature?
They are all the same.

Height Estimation Illusion

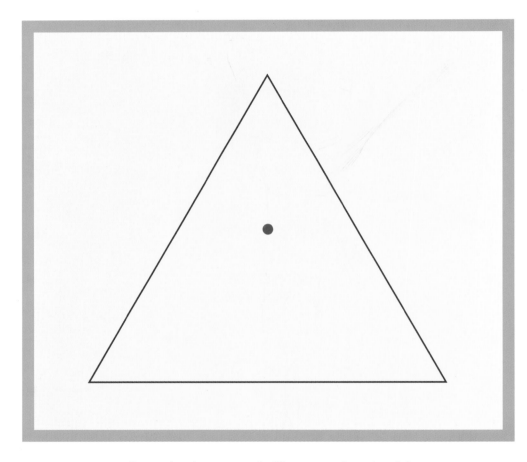

Does the dot appear half way up the triangle?
Check your answer with a ruler.

Orbison Illusion

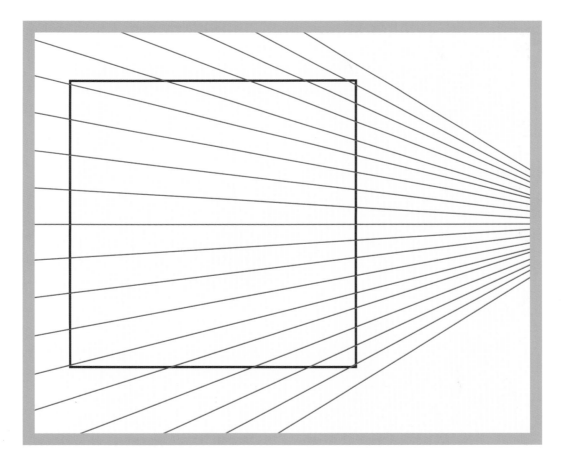

Does this square appear to be warped? Check your answer with a straightedge or just trace the outline of the square.

Which is the Shorter Line?

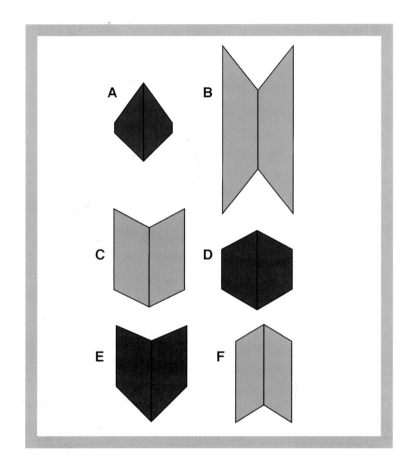

Which middle line (A, B, C, D, E, F) is the shortest line segment?
Check your answer with a ruler.

The Ames Room Illusion

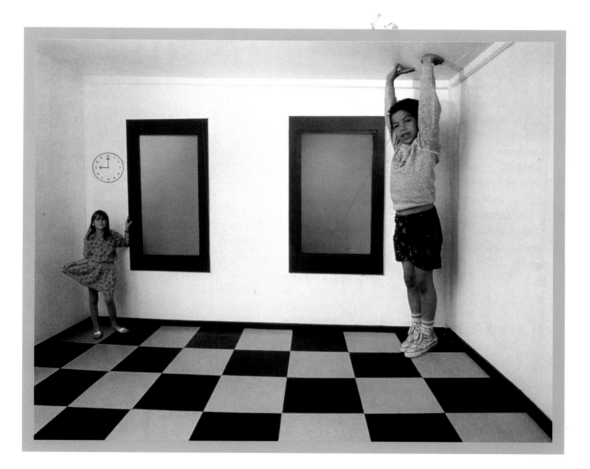

Although the girl appears to be smaller than the boy, she is really the same size. In addition, the room looks cubic, but the left corner is really twice as far away and at a lower elevation than the right corner.

Pinna's Deforming Square Illusion

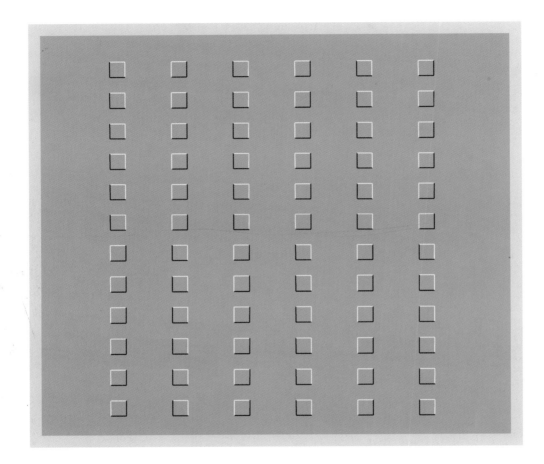

Slowly move this image up and down and the columns of squares will appear to separate from each other.

Curved Lines illusion

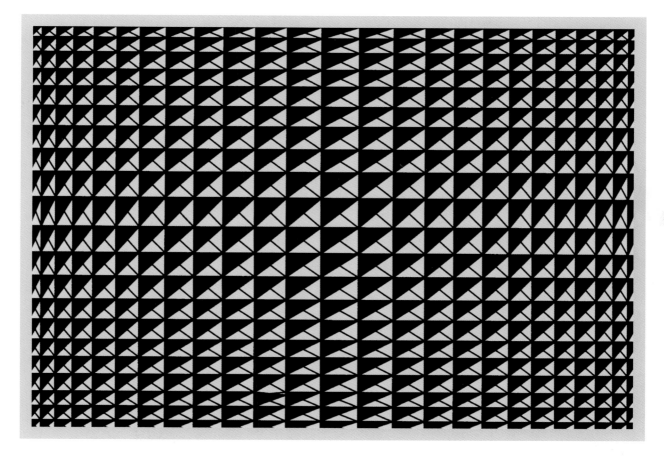

Do the lines between the black and yellow triangles appear to curve?
Check your answer with a straightedge.

Fisheye Illusion

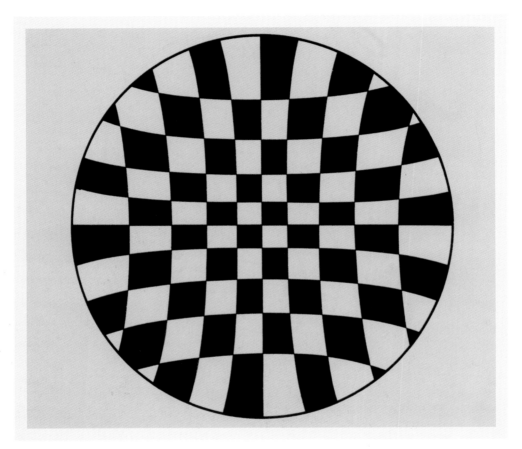

Move this image slowly towards one eye and the lines will straighten out.

An Illusion of Context

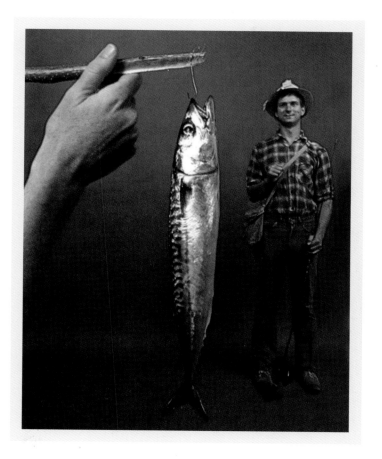

Cover the man and the fish looks like a normal catch.
Cover the hand and the fish looks massive.

Foreshortening Illusion

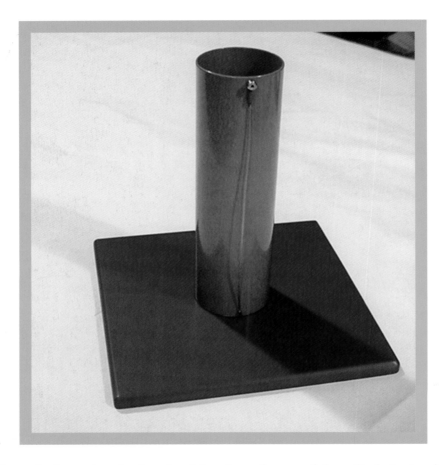

If you had a string the length of the circumference of the cylinder's rim, how far down would it go? Try this illusion with the inside of a paper towel roll.

Size Distance Illusion

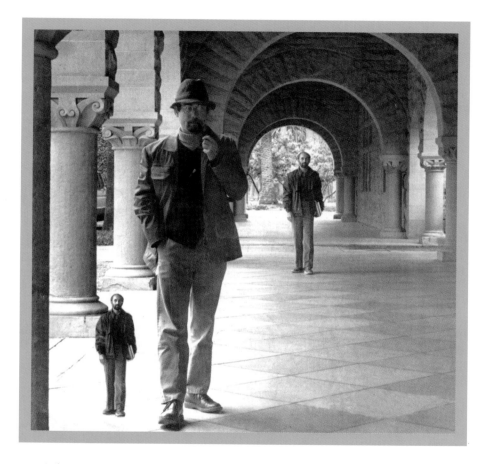

*The man on the left looks like a midget, but he is the same size
as the man in the background.*

Stack of Coins Illusion

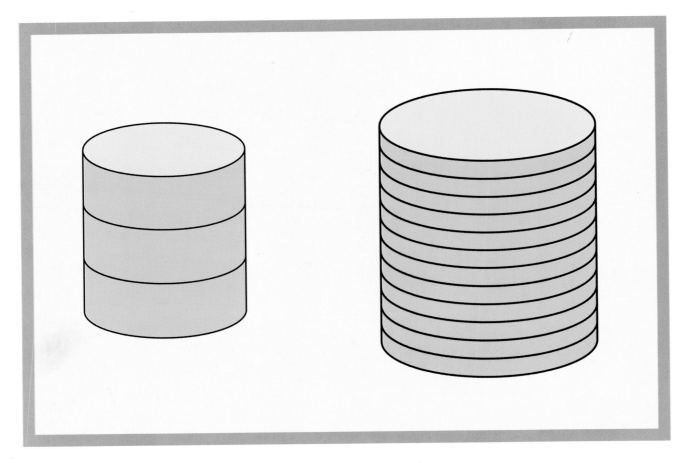

Which stack of coins is higher?

Terra Subterranea

*Does the creature in the background appear to be larger
than the creature in the foreground?
Check your answer with a ruler.*

Odd Balconies

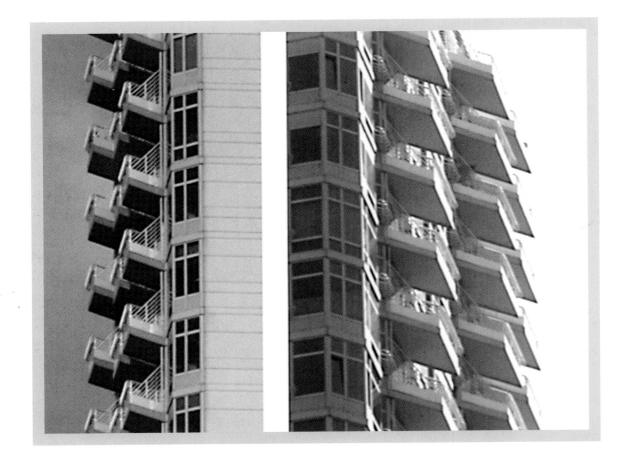

This is an odd building in New York City. From one side the balconies appear to be tilting upwards, but if you walk around to the other side, they appear to be tilting downward. How can that be?

Tilt

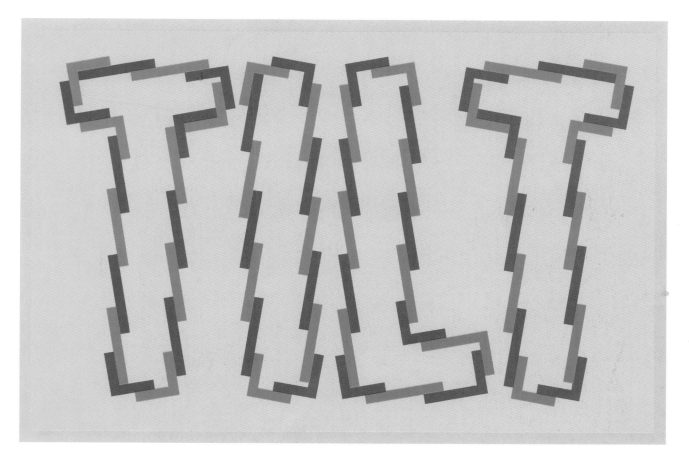

Do these letters appear to be tilted? Check your answer.

The Ponzo Illusion

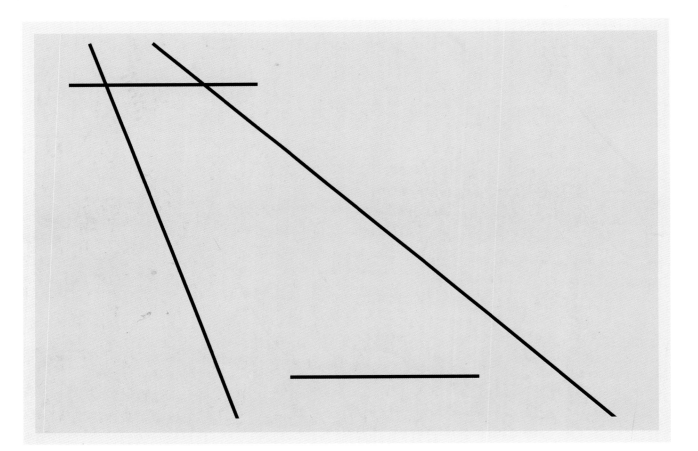

Which horizontal line appears longer?
Check your answer.

The Poggendorf Illusion

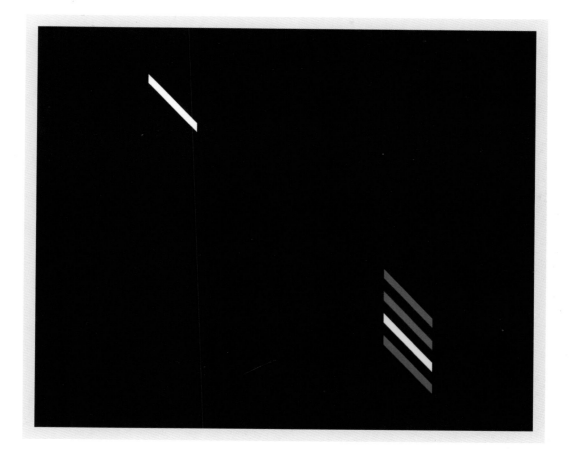

Which colored line intersects with the white line?
Check your answer with a straightedge.

The Plank Illusion

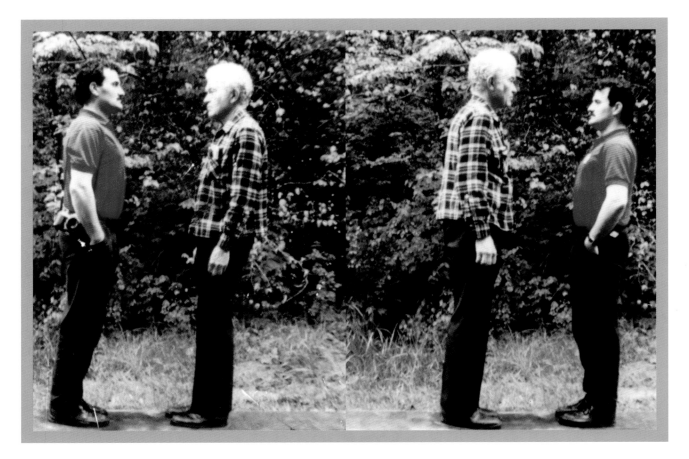

These two men appear to change in height, although all they have done is change exact places on a level plank.

The Wundt Illusion

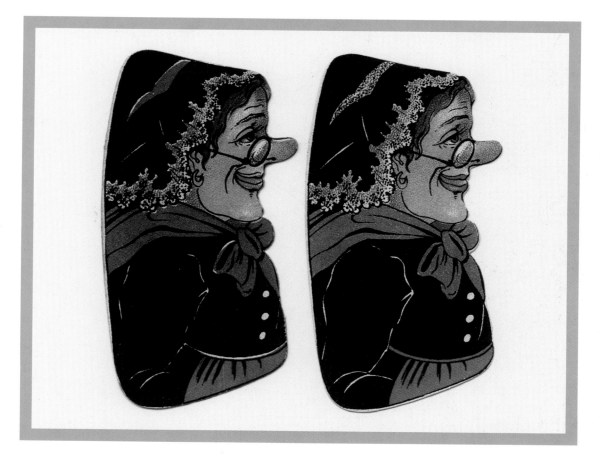

Does the figure on the left appear to be smaller than the figure on the right?
Check your answer.

Exploding Squares

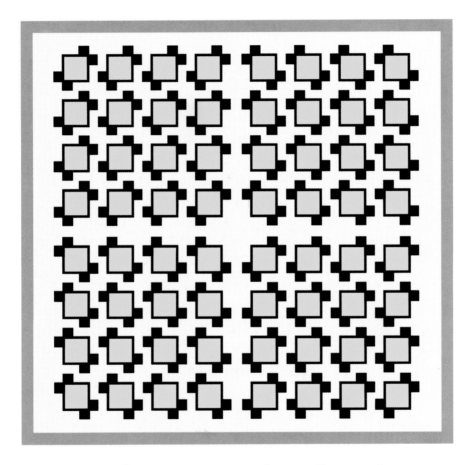

Do these squares appear to be spreading apart?

Distorted Circles

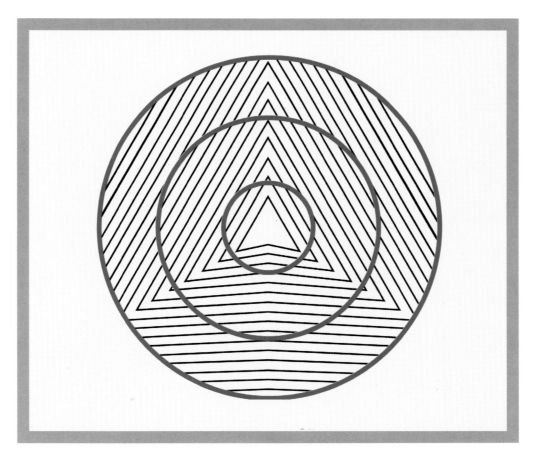

Do these circles appear to be distorted?

Poggendorf Illusion with a Circle

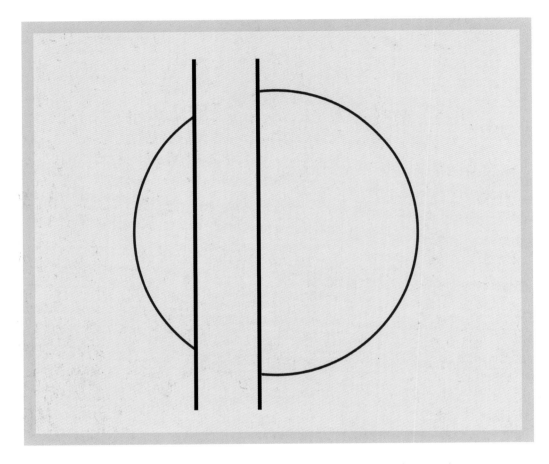

Is this a perfect circle? Does it appear to be aligned properly?

The Café Wall Illusion

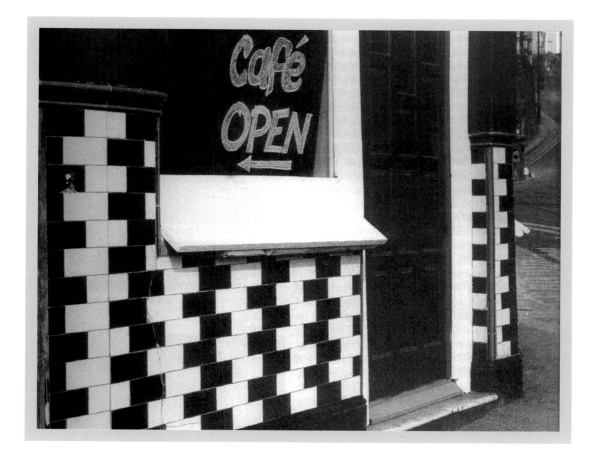

The pattern on the wall appears to be in wedges, but all the horizontal lines are straight and parallel.

Day's Sine Illusion

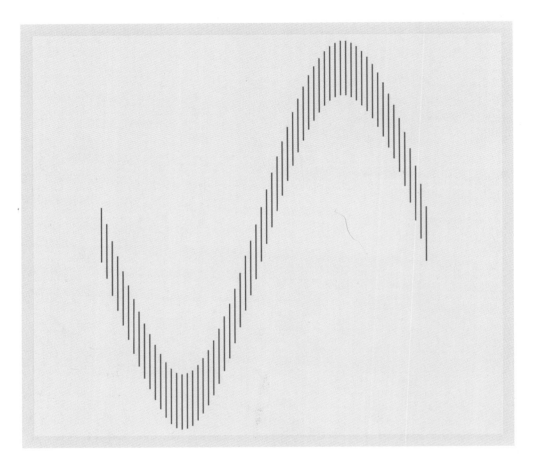

Do some line segments appear longer than others?
Check your answer with a ruler.

The Perspective Box Illusion

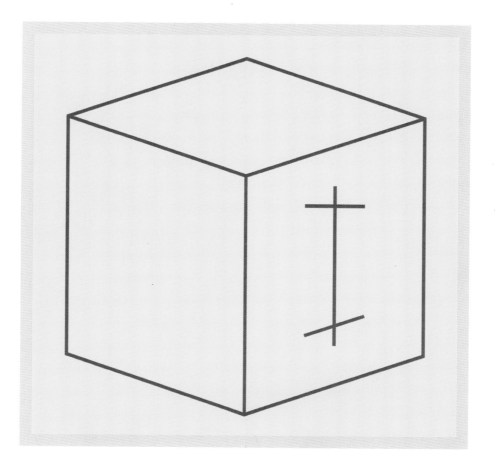

Look at the figure on the box and how the lines intersect.
Now cover just the box, but not the figure.
How do the lines intersect now?

Misaligned Dots

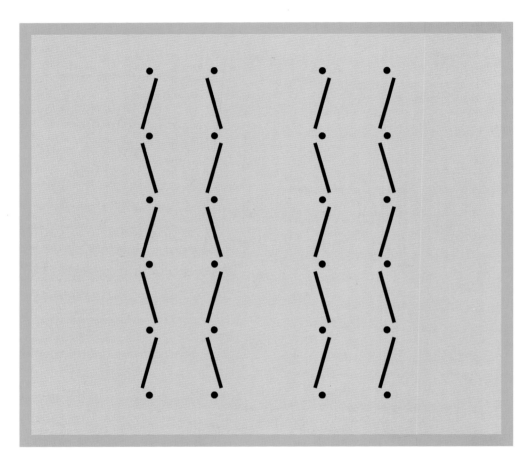

Do the dots appear misaligned?

Misaligned Eyes

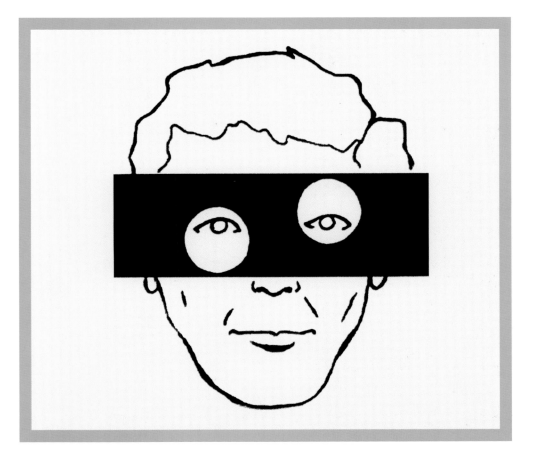

Do the eyes appear misaligned?

Illusory Triangle

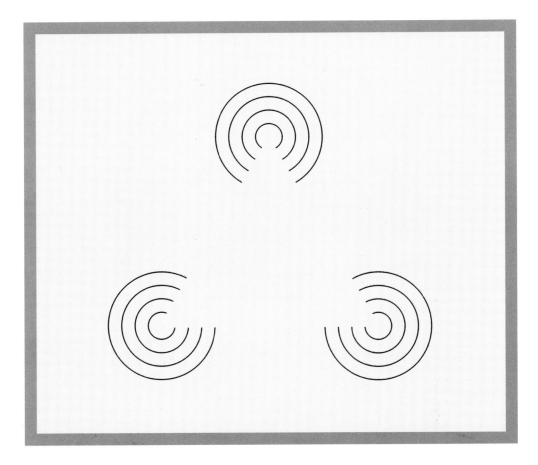

Do you perceive a triangle here? There are no edges to define it.

Potholder

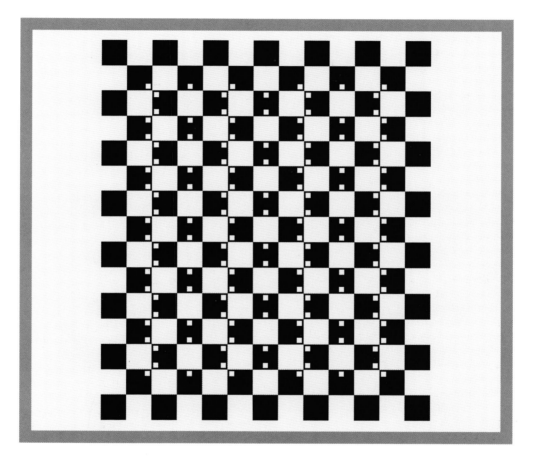

Do the lines appear to be bent? Check your answer with a ruler.

Purves and Lotto's Perspective Illusion

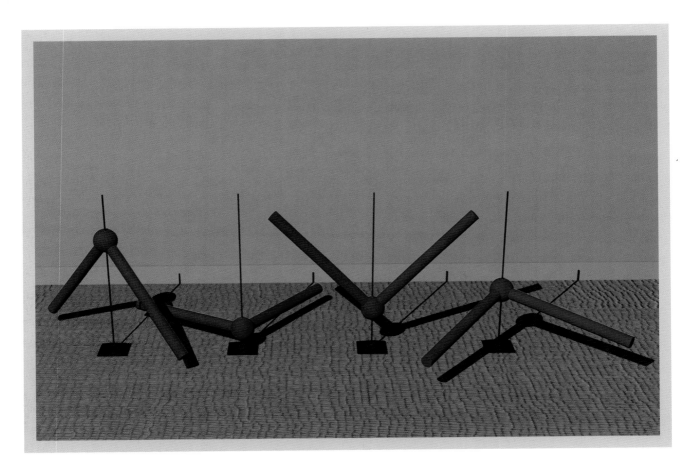

Do all the angles appear to be the same? Check your answer.

Ehrenstein Illusion

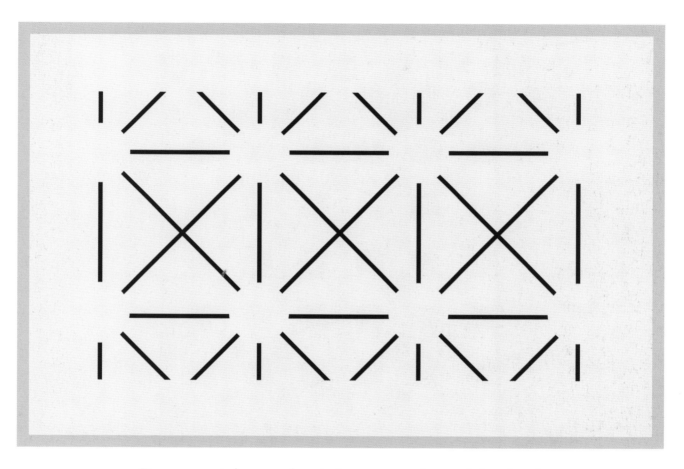

Do you see circles even though there are no edges to define them?

Boli of Bugs

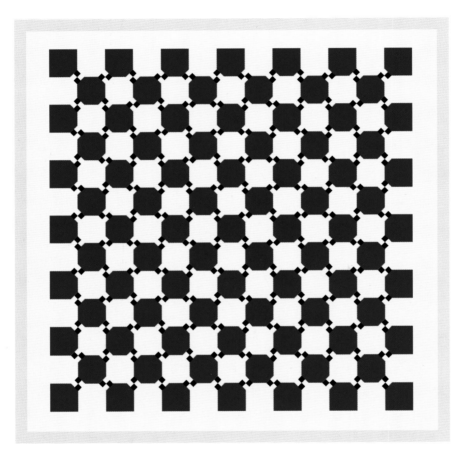

All the lines are straight and parallel.

The Hering Figure

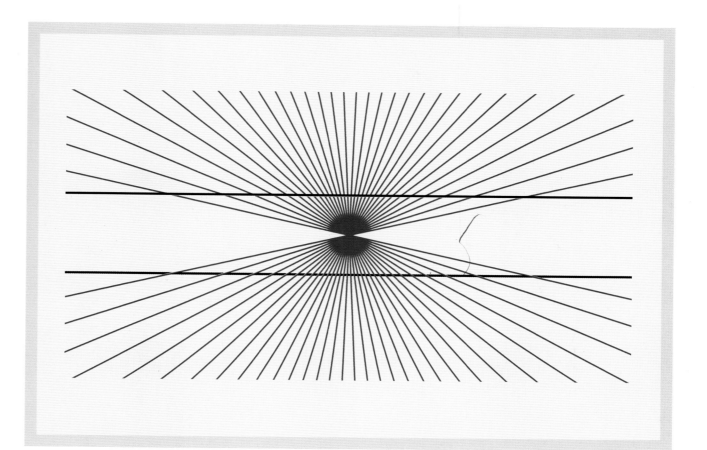

Do these lines appear to bend in the middle?
Check your answer with a straightedge.

Müller-Lyer in Perspective

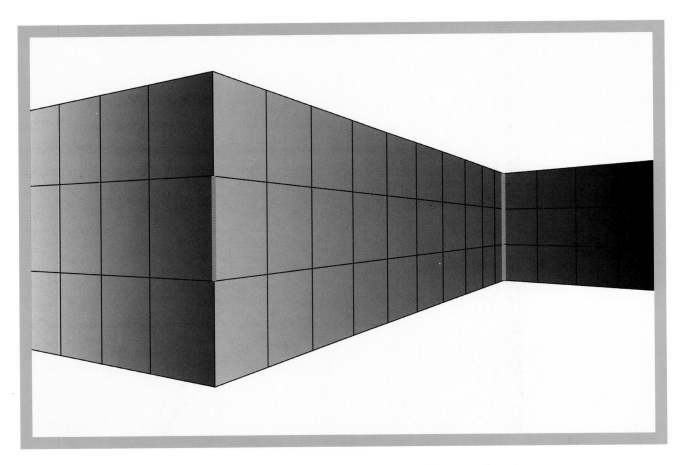

*Although the two red lines appear to be different in length,
they are identical.*

Wade's Spiral

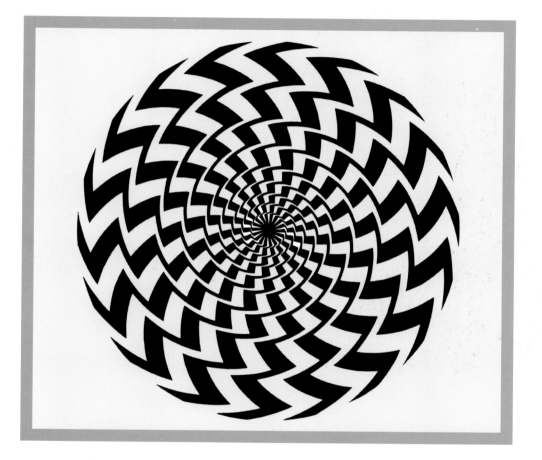

Do you perceive a spiral? It is really just concentric circles.

Off the Wall

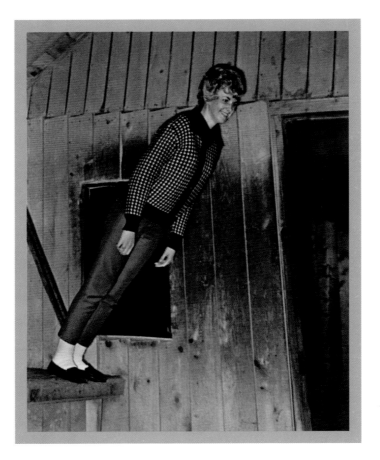

This woman appears to be hanging off the wall, but it is really the house that is slanted, not her.

Poggendorf Illusion

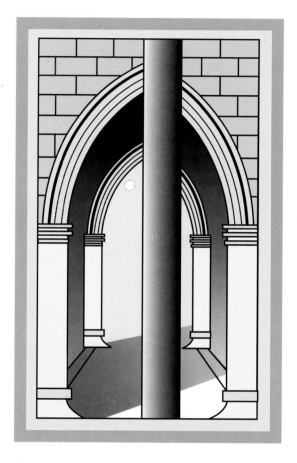

Does the arch behind the pillar appear to be misaligned?

Poggendorf Puzzle

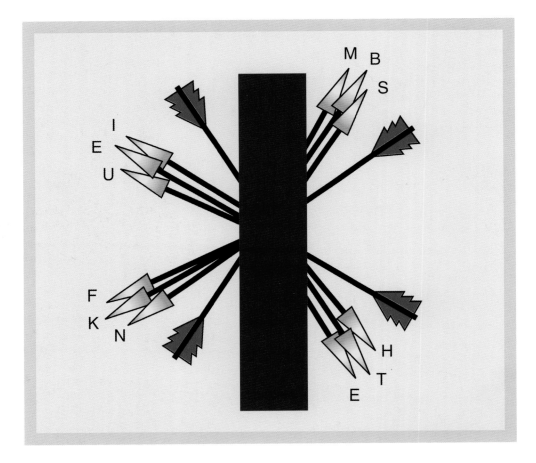

Connect the right arrows with the right fins and it will spell a word.
(Counterclockwise from the upper right.)

The Ponzo Illusion

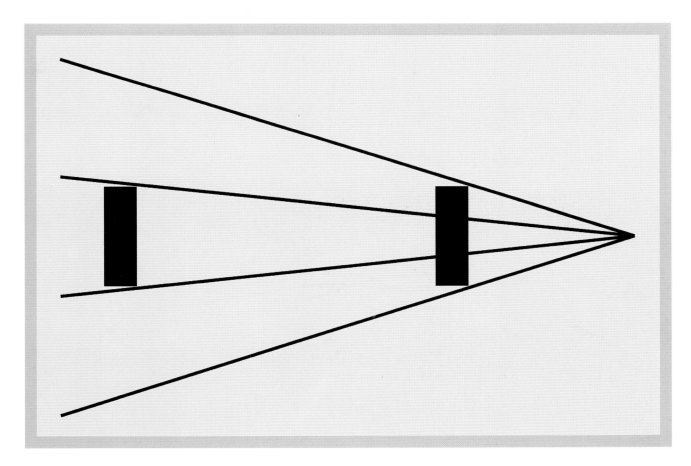

Does one bar appear larger than the other?
Check your answer.

Pinna's Revolving Circle Illusion

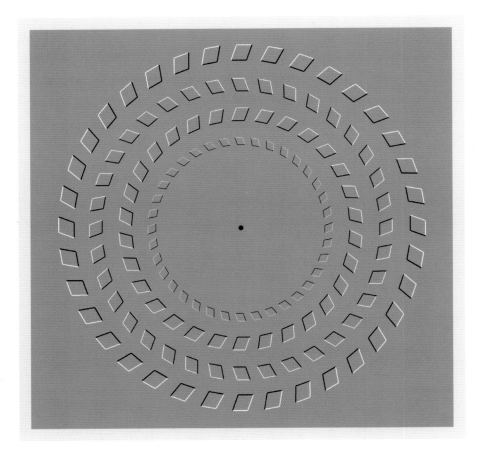

Move this image slowly towards your face and away from it.
The circles should counter rotate.

The Top Hat Illusion

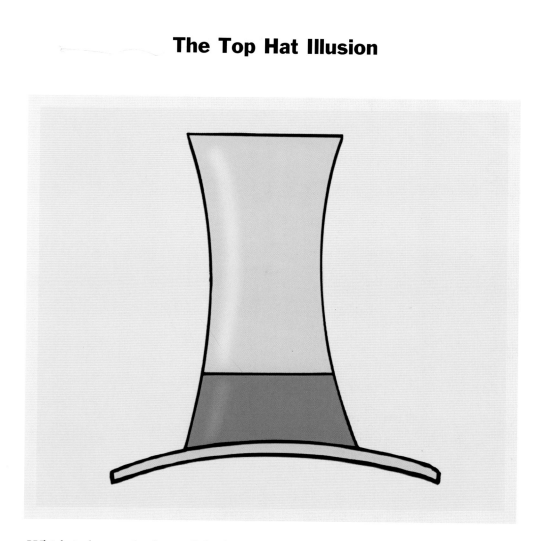

Which is longer the base of the hat or the length of the hat from top to bottom?
Check your answer with a ruler.

Tilted Houses

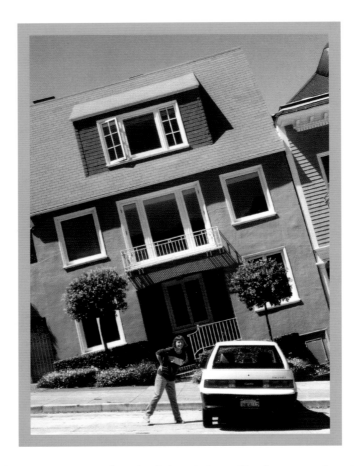

These houses appear to be tilted, but it is really the street that is tilted.

Twist on a Square of Three

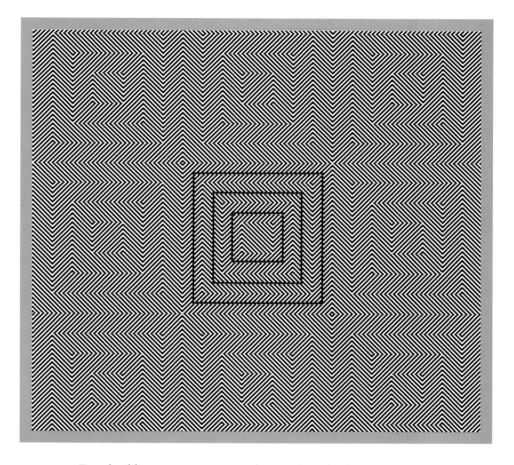

Do the blue squares appear distorted? Check your answer.
Try jiggling the image for another cool effect.

Deforming Squares

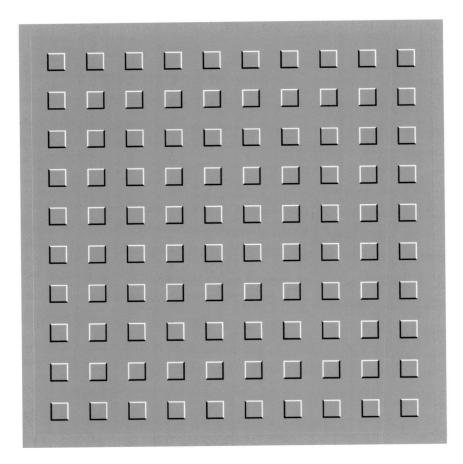

Move this image slightly and the squares will appear to deform.

Fukuda's Distorted Piano

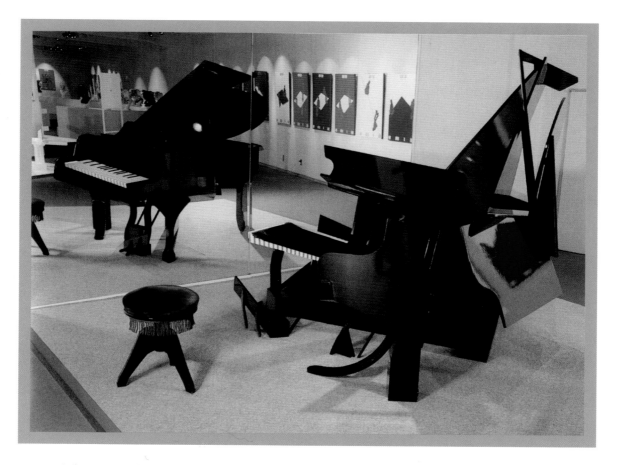

The mass of unrecognizable parts on the right casts a perfect reflection of a piano in the mirror on the left.

Trapezoid Illusion

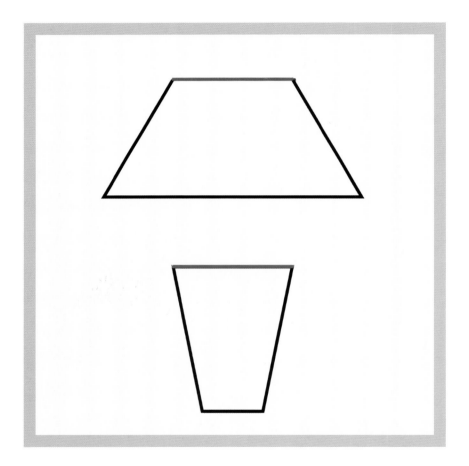

Which line segment is longer? The blue one or the red one?
Check your answer.

An Illusion of Extent

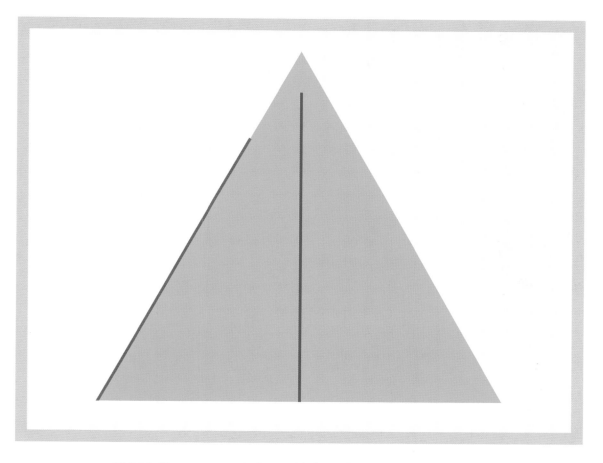

Which line segment is longer? The red one or the green one?
Check your answer.

The Twisted Cord Illusion

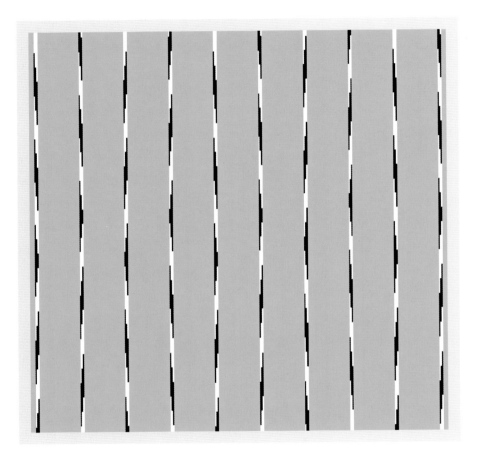

Do the vertical lines appear to be bent?
Check your answer with a straightedge.

The Striped Bars Illusion

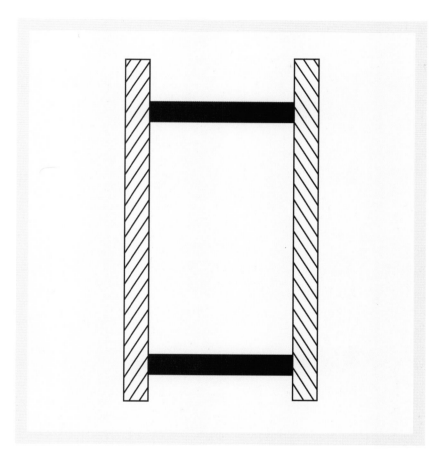

Do the striped bars appear to be leaning outward?

The St. Louis Arch Illusion

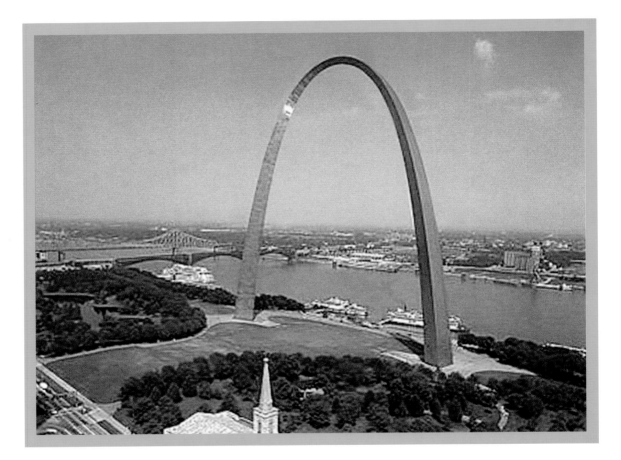

The St. Louis Arch is a famous national monument that is also an illusion.
It is as tall as it is wide, even though it appears taller than it is wide.

Kozall

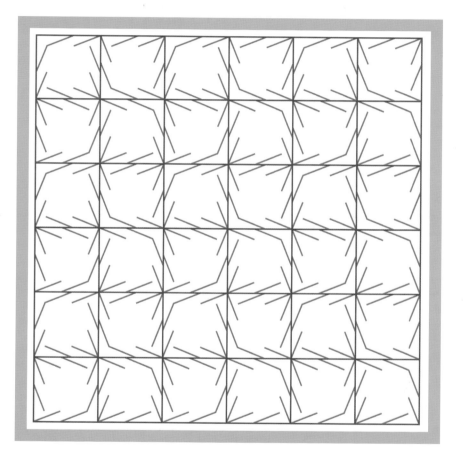

Are the vertical and horizontal lines straight and parallel?

SUPER VISIONS: **Geometric Optical Illusions**

Wundt Blocks Illusion

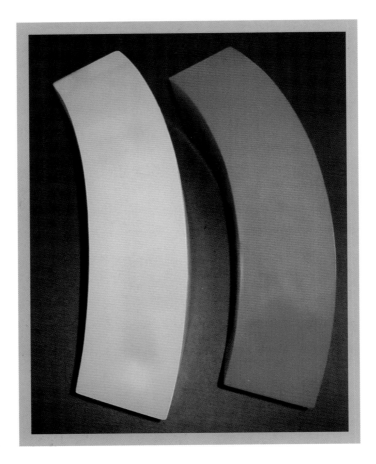

Which colored block is larger? Or are they the same size?

The Zöllner Illusion

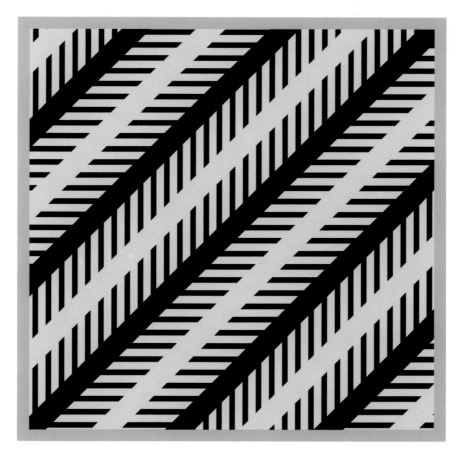

Do the black and yellow lines appear to bend?

Waves

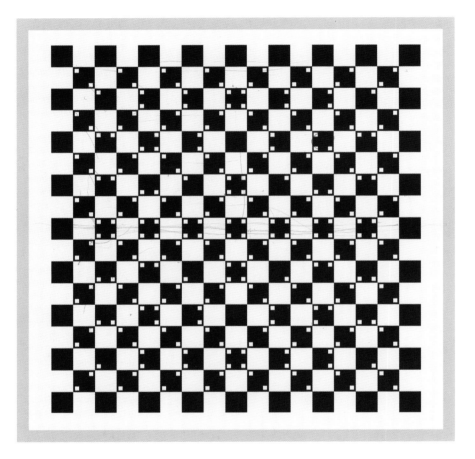

Are the lines really straight? Check your answer with a straightedge.

Illusory Sphere

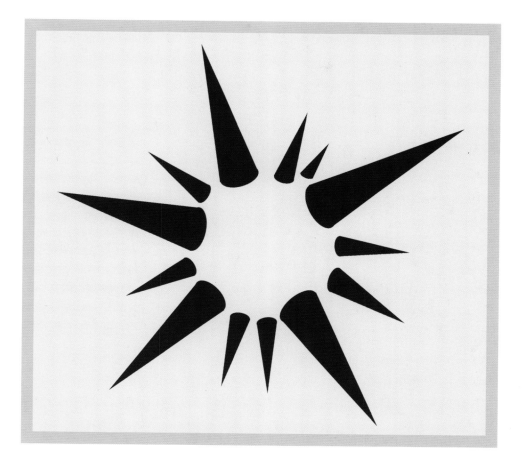

Do you perceive a sphere even though there are no edges to define it?

The Opel-Kundt Illusion

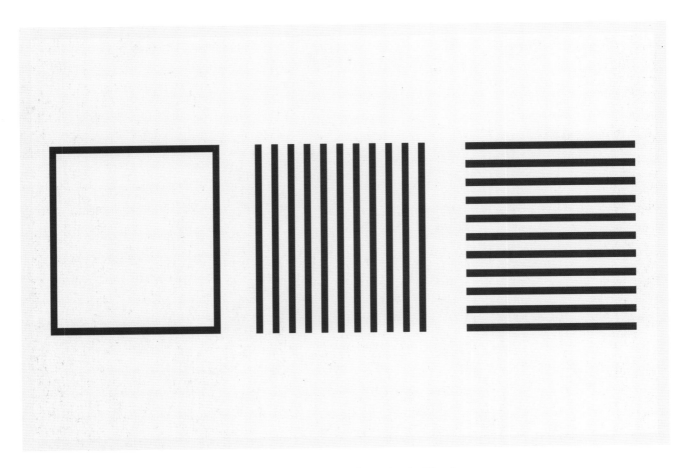

Do all three squares appear equal in size? Check your answer.

Crazy Street

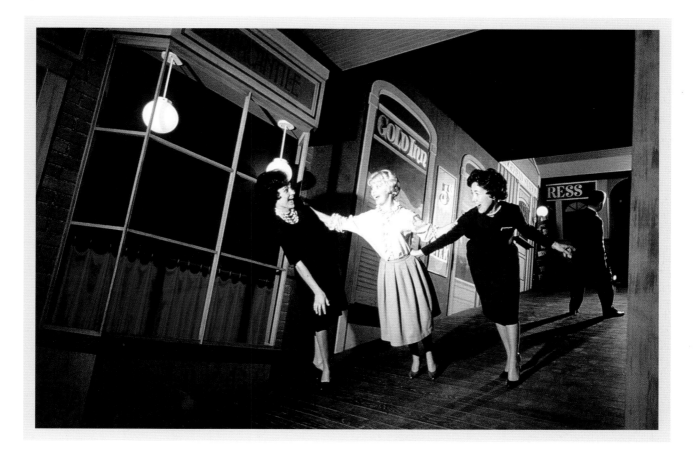

These people appear to be leaning, but it is the background that is sloping not the people.

Misalignment of Balls

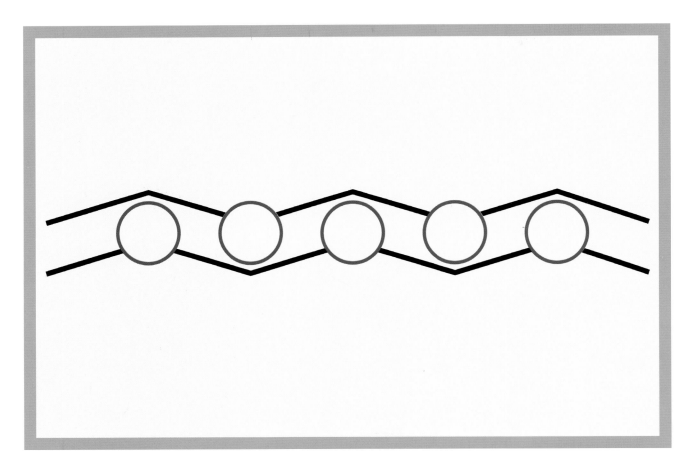

Do the balls appear to be misaligned? Check your answer with a ruler.

The Tilt Induction Effect

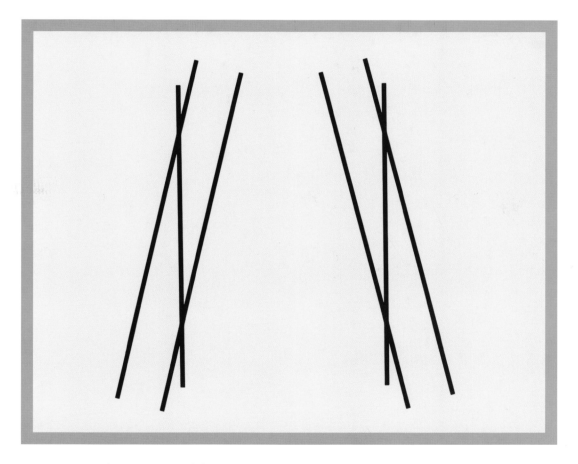

Do the two vertical lines appear to be slanting away from each other?
Check your answer with a ruler.

Distorted Square

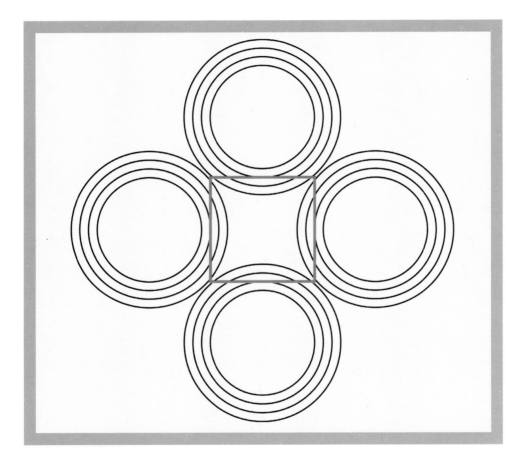

Is this a perfect square? Check your answer.

Blakemore's Tilt Illusion

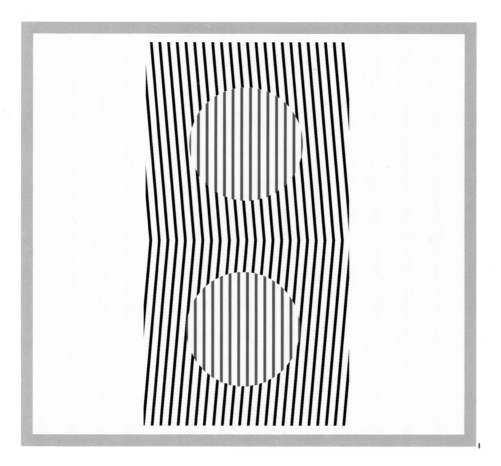

Do the red line segments appear to be tilted?
Check your answer.

Dango

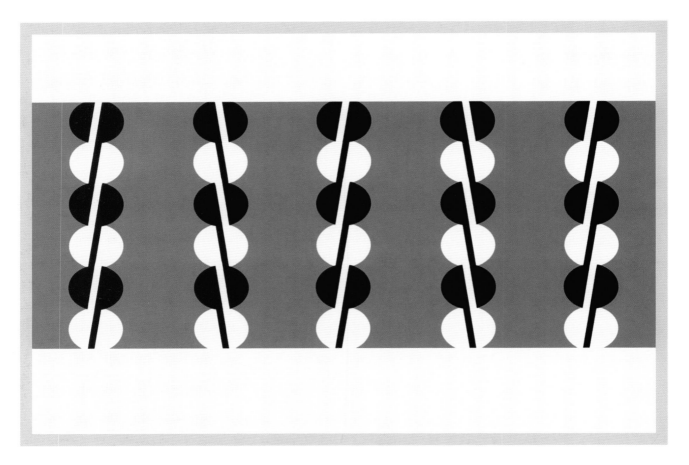

Do the vertical line segments appear to be tilted? Check your answer.

The Judd Illusion

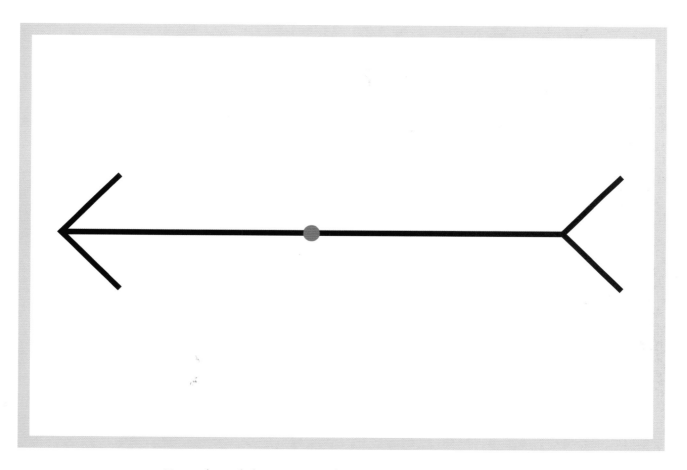

Does the red dot appear to be in the middle of the arrow?
Check your answer with a ruler.

Wilcox's Twisted Circle Illusion

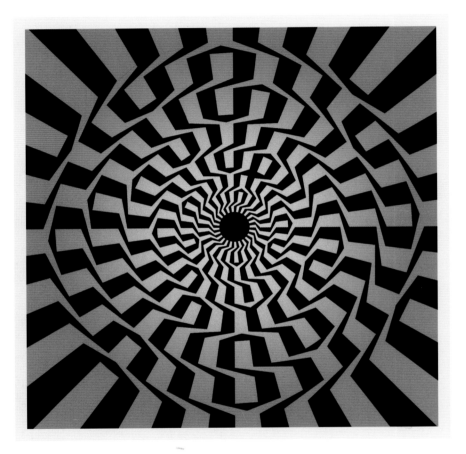

*Do you perceive a series of warped circles? They are all perfect circles!
Check this.*

The Jagged Line Illusion

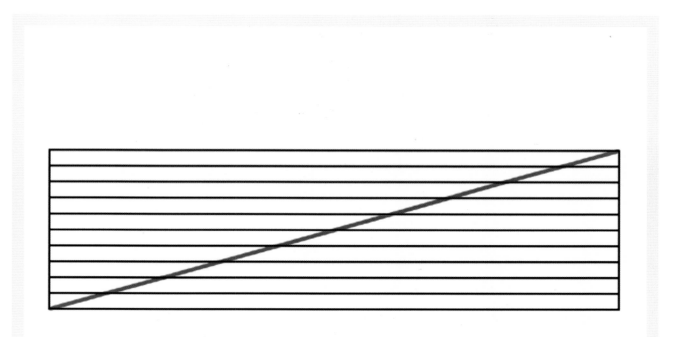

Does the red line appear jagged?
Check your answer with a straightedge.

Bulging Lines

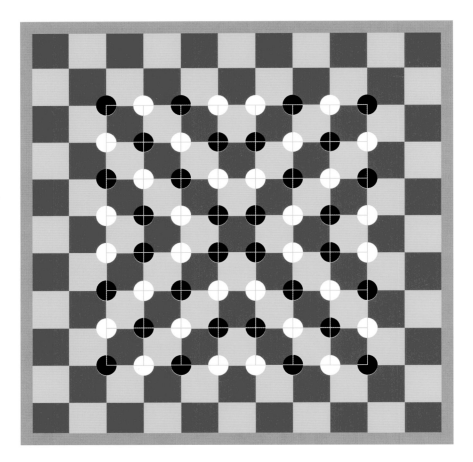

Do the horizontal and vertical lines appear to bulge?
Check your answer with a straightedge.

Straight Lines?

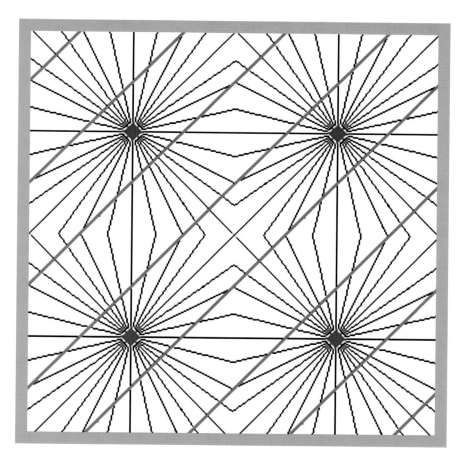

Are the red lines straight and parallel?
Check your answer with a straightedge.

The Greatest Illusion of Antiquity

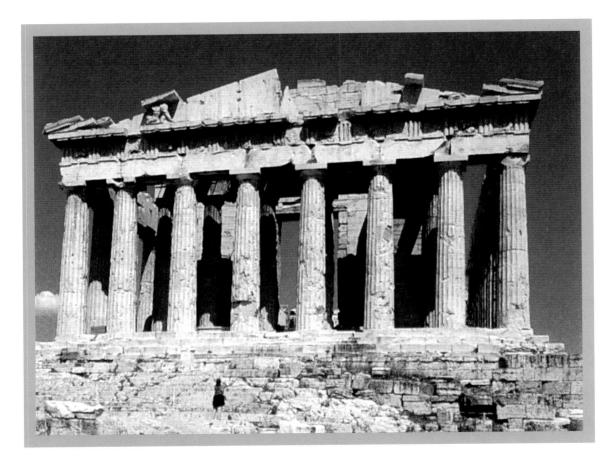

The Greek Parthenon is one of the great illusionistic buildings. All the columns appear straight and of the same thickness, but they are really bowed.

A Slight Bend

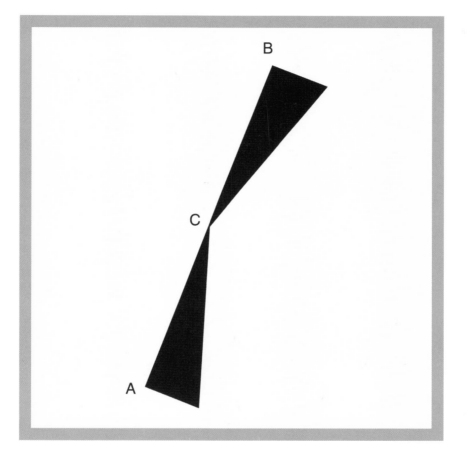

Does the line AB appear to slightly bend at C?

An Estimation Illusion

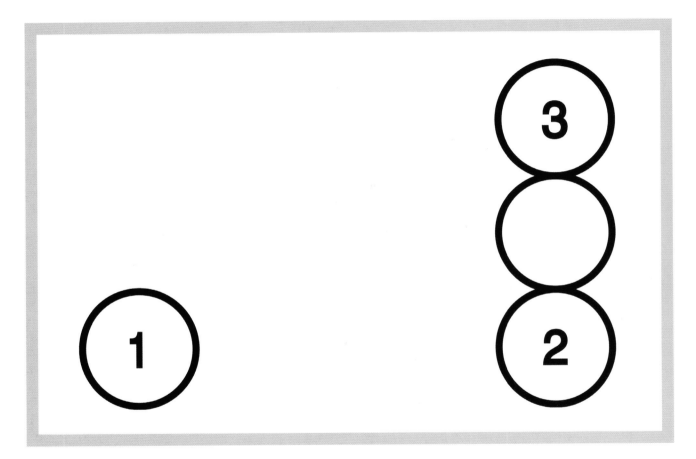

Which is the greater distance—between 1 and 2 or between 2 and 3? Check your answer with a ruler.

The Ebbinghouse Illusion

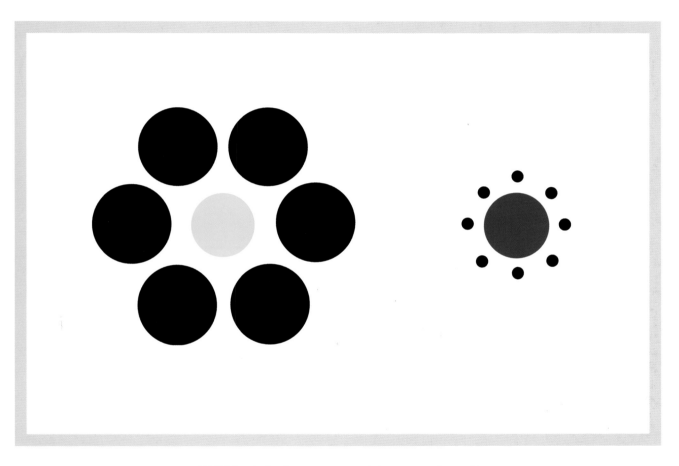

Which circle (green or purple) appears larger?
Check your answer.

Crooked Lines

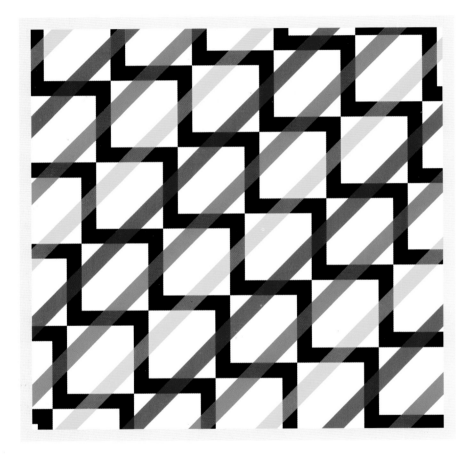

Do the edges of the colored bands appear to be wavy?
They are straight

What Does This Say?

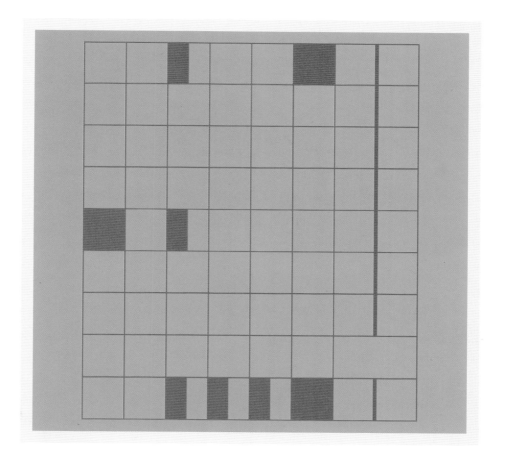

What does this say?

Distorted Squares

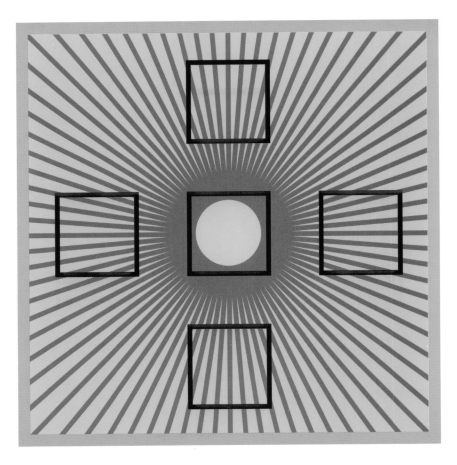

Do these squares appear distorted?

An Estimation Illusion

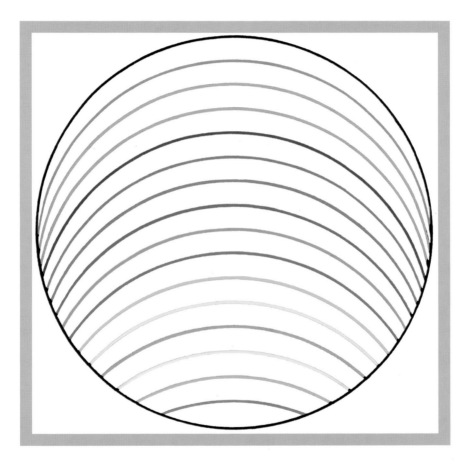

Which colored arc segment is in the exact center of the circle?
Check your answer with a ruler.

Stretched Heads

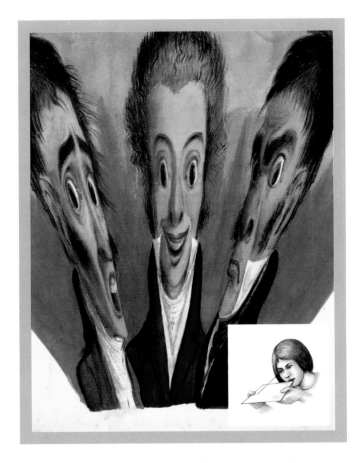

These three heads will not look distorted if you look at them the right way.
See insert.

Anamorphic Horse

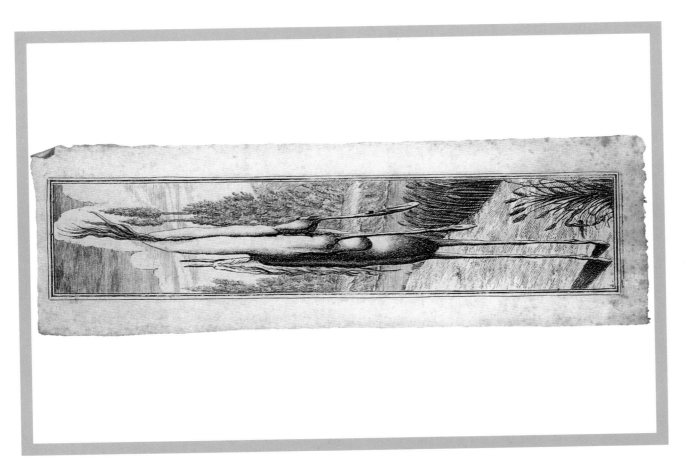

This horse can be seen as a normal horse if you look at it from the right edge, at a low angle

Kitaoka's Soccer Illusion

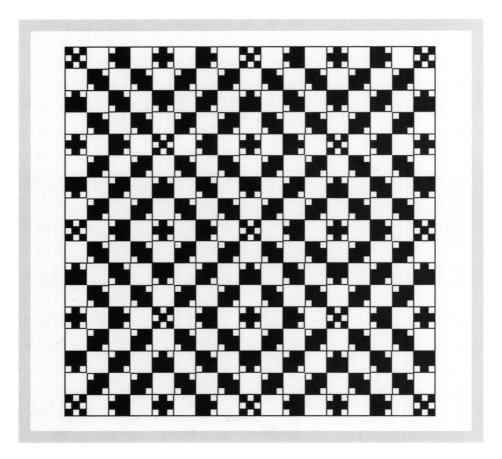

Would you believe that all the horizontal and vertical lines are straight?

Misaligned Dots

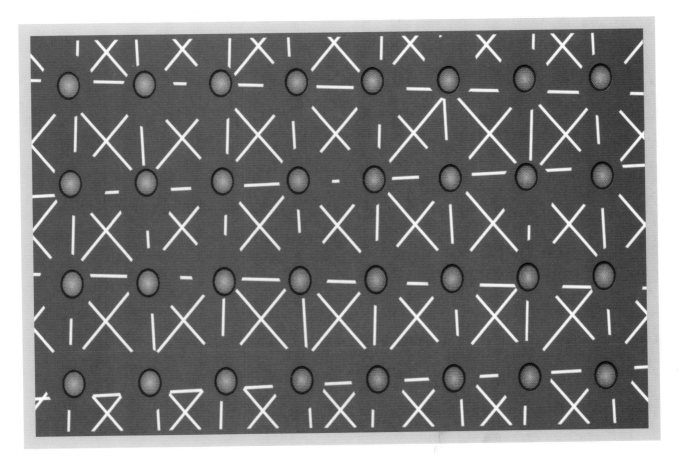

Do the purple balls appear misaligned?
Check your answer with a straightedge.

The Moon Illusion

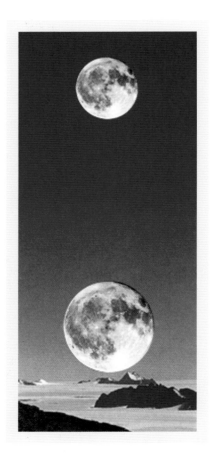

The moon illusion is one of the great natural illusions. A full moon appears larger on the horizon than when it is seen high in the sky.

INDEX

ABOUT THE AUTHOR

Al Seckel is the world's leading authority of visual and other types of sensory illusions, and has lectured extensively at the world's most prestigious universities. He has authored several award-winning books and collections of illusions, which explain the science underlying illusions and visual perception.

Please visit his website http://neuro.caltech.edu/~seckel for a listing of all of his books on illusions.